Drawing Book

Learn to Draw Superheroes

By Jess Well

Copyright©2015 Jess Well
All Rights Reserved

Table of Contents

Disclaimer

While all attempts have been made to verify the information provided in this book, the author does assume any responsibility for errors, omissions, or contrary interpretations of the subject matter contained within. The information provided in this book is for educational and entertainment purposes only. The reader is responsible for his or her own actions and the author does not accept any responsibilities for any liabilities or damages, real or perceived, resulting from the use of this information.

The trademarks that are used are without any consent, and the publication of the trademark is without permission or backing by the trademark owner. All trademarks and brands within this book are for clarifying purposes only and are the owned by the owners themselves, not affiliated with this document.

Introduction

Firstly, you ought to make a representation for the superhero. You may make an oval shape as the essential portrayal of the head. When you draw it, you ought to make the upper part more expansive and the lower part smaller. All the more frequently, this shape can be utilized for both female and male superhero face. What's more, the main contrast is that the button piece of the male face is more squared.

Also, you may begin draw the parts with the aide of the lines. You ought to make some light lines on the head to separation it into four squares. With the aide of these lines, you will have the capacity to make the essential parts be made in the best possible spots. At that point, you may draw two lines with one upward and the other descending to make the essential state of the eyes. After that, make a circle between these two lines to make eyes. You may attract some shade to make eyebrows. At that point, you may make the nose, ears and mouth with the rules. On the other hand you may take out the photo and make it as the photo appears.

The to wrap things up, you may need to right and attempt to make it look great. When you wrap up the essential parts of the head, you may make full utilization of the shading to include measurement. For instance, you may make some shading on the sides of the nose to make it look all the more clearly. All the more regularly, sharp calculated lines will make the face look more grounded. After that, you can utilize circles or lines to make the legend's hair. When you complete these, you may eradicate the light lines and look at whether there is have to adjust.

Toons have dependably been the first love of children. They watch kid's shows on TV more than grown-ups watch the news. Enlivened characters pull in their consideration combined with the tyke amicable story-line and sound impacts.

In this phase of their lives, toons are their way of life. They play with their toy toon characters, their school supplies have their most loved cartoon legend, and they even have an outfit of their most loved superhero.

In right on time school days, drawing is first lesson that is acquainted with children practically the same time with composing letters. It is not shocking that a few children adoration to draw their most loved toon characters for their drawing assignments, and even once in a while to the point of not focusing in class.

Chapter 1 – How to draw Captain America

Introduction: Start drawing Marvel's Captain America with a pencil sketch. At the outset stages, don't squeeze down too hard. Utilize light, smooth strokes for portraying.

Step 1: To draw Captain America, begin with an oval amidst the page. Underneath the oval, draw two little vertical lines on either side. This will be the fundamental shape for Captain America's head and neck.

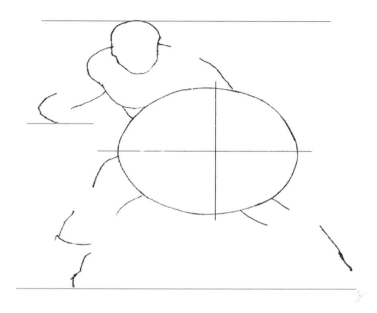

Step 2: Inside the oval, draw two crossing lines, one vertical and one flat. Underneath the level line, draw two littler flat lines. These will be development lines that will assist you with setting Captain America's components later on.

Step 3: Right on top of the level line and on either side of the vertical line, draw Captain America's eyes, which take after two little football shapes. At every end of the level development line, draw two bended lines that resemble the letter C for this comic book legend's ears.

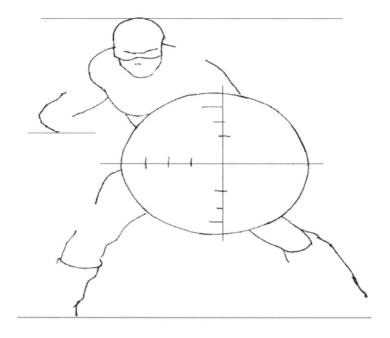

Step 4: That's it for the beginning portrayal of Marvel Comics' Captain America. You have the essential Captain America shape so now go in and fix you're drawing.

Step 5: Using the introductory shapes as aides, obscure Captain America's eyes all around to speak to eyelashes. At the point when drawing the eyes, twist the base piece of every eye a little to give him a slight squint.

Step 6: Inside every eye, attract a circle to speak to Captain America's iris. Inside every iris, draw a bow moon and shade it in. This will be Captain America's understudy. The base part will go about as glare.

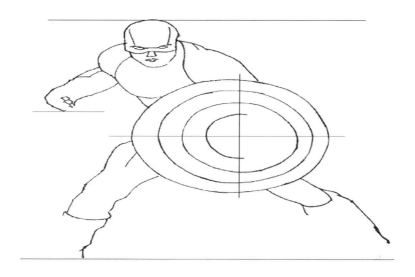

Step 7: Add the openings of Captain America's face cover, which thusly make his eyebrows. Begin by attracting what give off an impression of being check marks over his eyes, then keep circumventing his eye until the line meets once more. In the middle of his eyes, draw a little line for a wrinkle.

Step 8: Above the little even line, attract to little bends to speak to Captain America's nostrils. On either side of these lines, draw two little vertical lines to speak to the sides of his nose.

Step 9: Draw the scaffold of Captain America's nose as a broken vertical line that stretches out from in the middle of his nostrils upward. End the line in the middle of his eyes. Draw a couple more lines for additional point of interest.

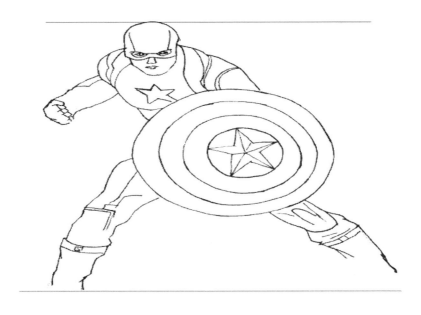

Step 11: Above Captain America's eyes and amidst his temple, draw a striking letter A. Utilize the vertical development line to assist you with finding the center.

Step 12: On either side of the An on the sides of Captain America's head, draw little wings that are a piece of his cover. These can be dubious so utilize the picture above for reference when drawing Captain America's cover.

Step 13: Captain America's veil doesn't cover his mouth or nose so draw a bended line over his nose and one on every side of his face to make this opening in his cover.

Step 14: Now utilize the base piece of the oval as an aide and attract Captain America's lower jaw. It begins underneath the primary even development line. Make this Marvel Comics legend cheekbones and make the shape more square at the base. On the off chance that you'd like, you can draw a little line on Captain America's button for a separated.

Step 15: Captain America's ears are additionally outside his cover so utilize the introductory shapes as aides and add point of interest to give them structure.

Step 16: Use the top piece of the oval to draw Captain America's head. Inside his head, attract a couple lines to show the division between the plane of his temple and the highest point of his head.

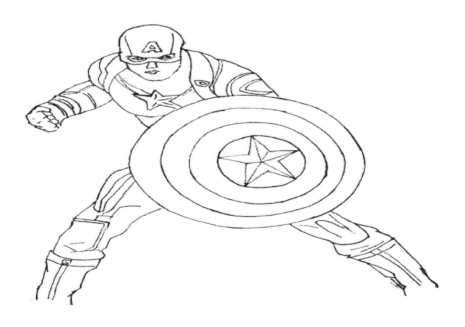

Last Step: For a totally completed Captain America drawing, you need to shading it. You can utilize markers, shading pencils or even pastels! Shading Captain America's eyes and veil blue and his skin peach.

Chapter 2 – How to draw hulk

Introduction: Start drawing Hulk with a pencil sketch. First and foremost stages, don't squeeze down too hard. Utilize light, smooth strokes for outlining.

Step 1: To draw Hulk, begin with a long oval with to some degree squared sides. This will be the fundamental shape for Hulk's head.

Step 2: Inside the oval draw two crossing lines, one vertical and one flat. At the point when drawing the even line, twist it a bit to form to the oval's shape. These will be development lines that will assist you with setting Hulk's elements later on.

Step 3: Right on top of the flat line and on either side of the vertical line, draw Hulk's eyes, which are two little football shapes.

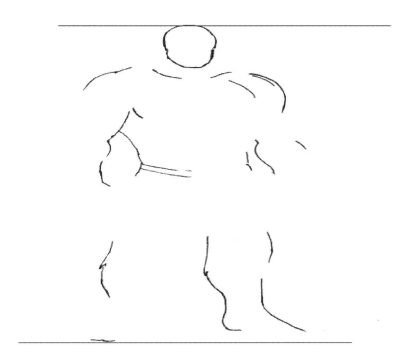

Step 4: Below that V shape, draw a long rectangle with adjusted corners for Hulk's mouth.

Step 5: Draw a bended line that resembles the letter C on either side of Hulk's head for his ears. Draw Hulk's ears somewhat higher than the level development line on the grounds that he will be looking down menacingly.

Step 6: Tighten the shapes darkening so as to encompass Hulk's eyes them. The shapes wrap around his eyes and tilt up toward his ears.

Step 7: Finish Hulk's eyeballs, which are a progression of circles. Draw a little shaded circle for his understudy, a greater circle around that speaks to his iris and a little hover toward the eye's edge to speak to glare.

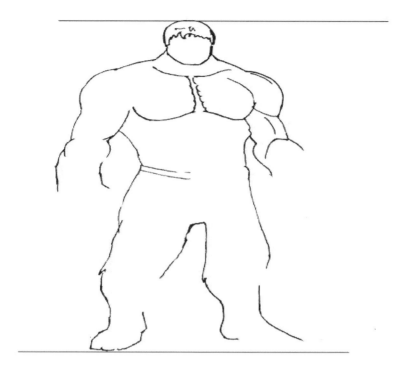

Step 8: Hulk is constantly furious (which is the reason Bruce Banner changes into Hulk!), so give him a glare. Draw lines around Hulk's eyes for point of interest on his forehead.

Step 9: Darken in Hulk's nose and draw the extension of it, which descends as lines from the internal corners of his eyes. Give Hulk some scowl lines that stretch out to the sides of his mouth.

Step 10: Tighten the state of Hulk's mouth. He will be gritting his teeth so attract some shading to the sides of his mouth and minor lines that look like in addition to signs to go on the defensive meet up.

Step 11: Add two lines underneath Hulk's mouth to show his lips. Likewise attract several lines over his mouth for point of interest.

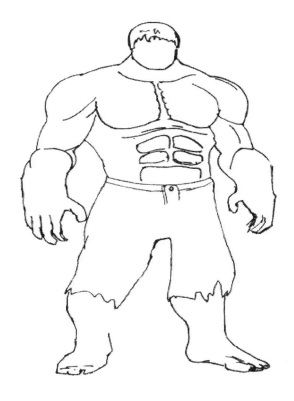

Step 12: Hulk's hair resembles a toupee on his head. The hair is a touch dubious so this area about how to draw Hulk's hair is separated into four sections. In the first place draw the bit of hair that comes over his temple. It's essentially a group of bended triangles of distinctive sizes.

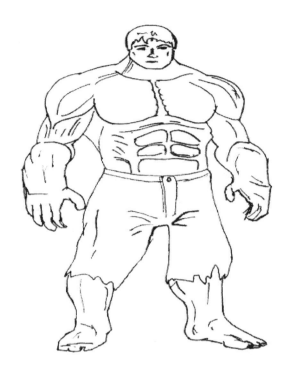

Last Step: For a totally completed Hulk drawing, you need to shading it. You can utilize markers, shading pencils or even pastels! Mass is anything but difficult to shading. The non-shaded piece of his hair, his eyes and his gums are dull green. Whatever remains of Hulk is light green. That is it! You now have a finished drawing of Hulk from Marvel Comics.

Chapter 3 – How to draw a superhero

Step 1: Draw a little hover on the highest point of the page for the skull. Drop down a little opposite line bisecting the circle. Make a "U" at the circle's base. Put three little lines one beneath the other at the focal point of the opposite line.

Step 2: Draw five straight lines joining one another at points as appeared in the drawing. Join a precise box at the above's base shape. Make a little sporadic box for the right upper arm. Join another decreased box on the upper's end arm for the lower arm.

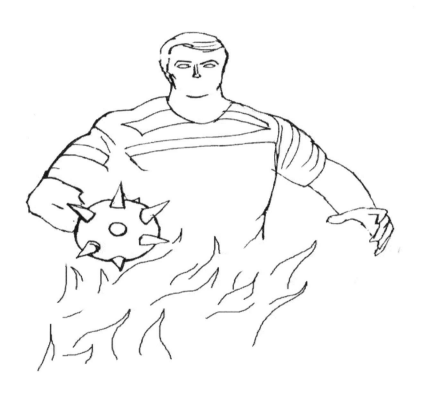

Step 3: Follow it with joining a five sided secured zone for the clench hand. Draw an oval for the thigh. Overlap it with another oval for the lower leg.

Step 4: Overlap the oval's base with a rectangle. Join another little opposite box from the above's base. Join a modified container at its base for the foot.

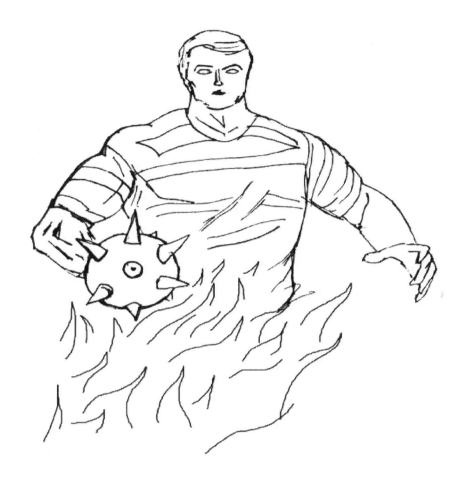

Step 5: Create another oval for the other thigh. Cover it with a little hover for the knee. Further cover it with another circle for the lower leg took after by a little oval for the other foot. Make a major oval for the shield in the position appeared. Put a few symmetrical lines for the advisers for the eyes.

Chapter 4 – How to draw a super girl

Step 1: Draw a stick figure of your miracle lady. In this delineation we attract her mid-air or flying.

Step 2: Flesh out your drawing.

Step 3: Draw the points of interest of the face. Draw the eyes nose and mouth somewhat open going on the defensive held together. The eyebrows marginally bended upwards and little line strokes close to the focal point of the eyes to make her look irate.

Step 4: Diagram her face including the ears and headband with a star in the middle.

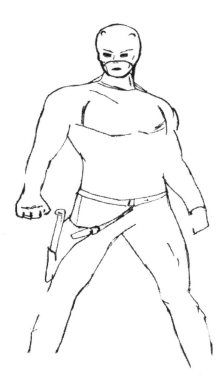

Step 5: Draw her hair, make it look wind-passed up utilizing bended strokes that stress development.

Step 6: Draw her outfit. Include stripes the mid-section part, stars on the hip, boots and her tether.

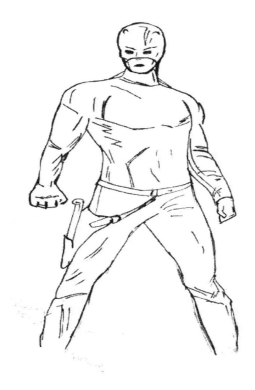

Step 7: Diagram her body. Add points of interest to the gripped clench hand.

Chapter 5 – How to draw Deadpool

Introduction: Start off with a pencil sketch. Before all else stages, don't squeeze down too hard. Utilize light, smooth strokes for outlining.

Step 1: Start by drawing a circle close to the highest point of the page. This will be the fundamental shape for the highest point of Deadpool's head. It doesn't need to be great. It's only an aide.

Step 2: Draw a bended U-molded line under the circle as an aide for Deadpool's button and jaw. Start to finish, the bend ought to be just about the same as the circle's measurement. Together these two shapes frame the aide for the head.

Step 3: Next, draw a vertical line that partitions the head similarly in two. This is a development line that will assist you with putting Deadpool's facial components later on.

Step 4: Draw two little shapes as aides for Deadpool's eyes. Draw them sitting on top of the base edge of the fundamental circle. The shapes ought to be like little footballs. Pay consideration on the separation between the eyes and the vertical development line.

Step 5: Under Deadpool's head, draw a progression of lines for the neck and top piece of the shoulders.

Step 6 (discretionary): On the top piece of every shoulder, draw a long corner to corner line as an aide for Deadpool's two katanas.

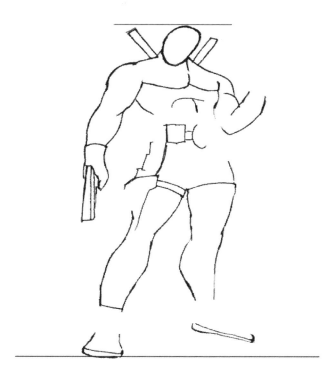

Step 7: That's it for the starting representation! You have the fundamental state of Marvel's Deadpool. Presently go in and fix you're drawing.

Step 8: Use the starting football-like advisers for draw the state of Deadpool's eyes. Take after the fundamental way of the aides however make the eye on the left more extensive as you obscure the line and the eye on the privilege littler. This gives Deadpool his exemplary entertaining, curious look.

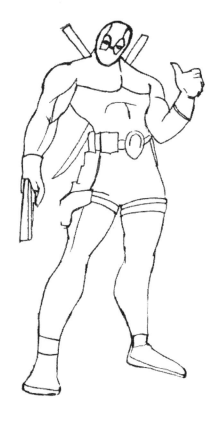

Step 9: Draw a line on top of every eye for the eyebrows. Similarly as with most comic book characters, you can at present see the framework of Deadpool's temples despite the fact that he wears a veil.

Step 10: Draw Deadpool's head utilizing the starting shapes as aides. Take after the shapes' way as you obscure the lines. Include an additional bended line either side of the head for the ears under the cover. You can likewise draw the additional piece of the veil on top of the head as a bended line.

Step 11: Now draw the veil's example. Deadpool's cover is extremely basic. It comprises of an oval-like shape that encompasses every eye.

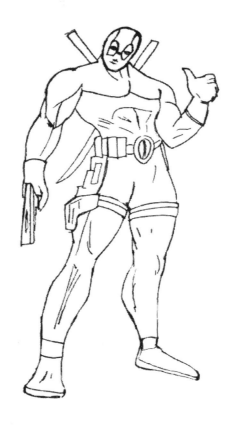

Step 12: Use the lines under Deadpool's head as advisers for draw the neck. Utilizing a progression of bended lines, draw the neckline around his neck. His jaw ought to hinder the front piece of the neckline.

Step 13: Now obscure the lines to shape the top part of Deadpool's shoulders. Draw the neck muscles under the neckline and the clavicle or neckline bones as well.

Step 14 (discretionary): You can skirt the following two stages on the off chance that you would prefer not to draw Wade's katanas on his back. Utilize the lines on the shoulders as advisers for draw the handles or grips of the katanas.

Last Step: For a totally completed Deadpool drawing, you need to shading it. You can utilize markers, shading pencils or even colored pencils! The handle and protect on the katanas alongside the neckline around his neck are dark. The casings and handles are dark. You can add more detail to the handles by including minimal red precious stones over the center to speak to the wrappings. The fundamental part of Deadpool's outfit is red.

Chapter 6 – How to draw Thor

Introduction: Start off with a pencil sketch. In the first place stages don't squeeze down too hard. Utilize light, smooth strokes for drawing.

Step 1: Start by drawing an oval amidst the page. Underneath the oval draw two little calculated lines on either side. This will be the essential shape for Thor's head and neck.

Step 2: Inside the oval draw two meeting lines, one vertical and one flat. Underneath the flat line draw two littler even lines.

Step 3: Right on top of the flat line and on either side of the vertical line, draw Thor's eyes, which take after two little football shapes.

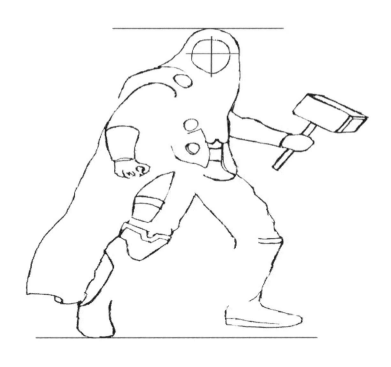

Step 4: At every end of the flat development line and on either side of the head, draw two long triangle-like shapes that will serve as aides for the wings on Thor's protective cap. The extent of the triangles decides the wings' span on Thor's cap. The more extended the triangles, the more drawn out the wings will be.

Step 5: On either side of Thor's head, underneath the triangles, draw two bended lines that reach out beneath his neck as aides for his long hair.

Step 6: That's it for the starting representation! You have the fundamental Thor shape so now go in and fix you're drawing.

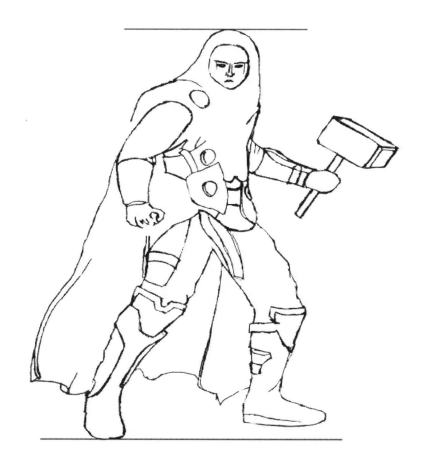

Step 7: Right over every eye, draw Thor's eyebrows. The eyebrows look like thick check marks. Edge them down toward the nose to give Thor a threatening glare.

Step 8: Using the starting shapes as aides, obscure this Marvel Comics character's eyes all around to speak to eyelashes.

Step 9: Inside every eye, draw a circle to speak to Thor's iris. Inside every iris draw a sickle moon and shade it in. This will be his understudy.

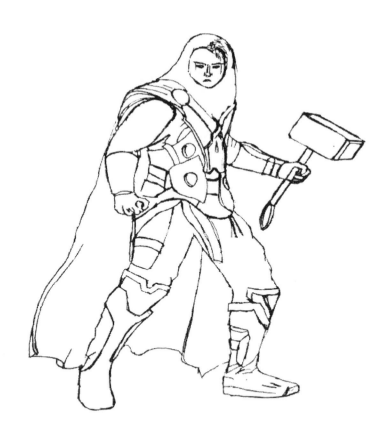

Step 10: Above the little even line, draw two little bends to speak to Thor's nostrils, and on either side of them draw two more bends, this time with a vertical introduction to speak to the sides of his nose.

Step 11: Draw the scaffold of Thor's nose as a broken vertical line that reaches out from in the middle of his nostrils up to in the middle of his eyes. Draw a couple more lines for additional point of interest.

Step 12: Using the most reduced of the flat lines as an aide for position, draw Thor's mouth. Twist the line descending to give Thor a slight scowl and draw another little line underneath it for his base lip.

Step 13: Use the introductory triangle shapes as advisers for draw in the wings in favor of Thor's head protector. Essentially include bended lines within the shape to frame wings. The plumes point up on top and steadily alter course and wind up indicating down at the base.

Step 14: There are a wide range of variants of Thor. Some of the time he has whiskers, and now and again he doesn't. The facial hair gives him to a greater degree a Viking look so how about we give him a whiskers.

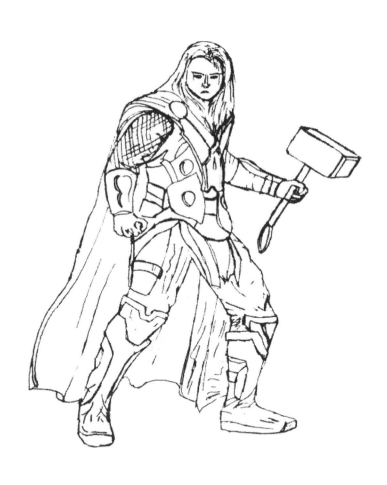

Step 15: Finish up Thor's whiskers by drawing another fluffy line and utilizing the base piece of the primary circle as an aide. Square the sides and button a bit to improve the jaw's state and keep in mind to utilize speedy, short strokes.

Last Step: For a totally completed Thor drawing, you need to shade it. You can utilize markers, shading pencils or even pastels! His hair, eyebrows and whiskers are fair so shading them in yellow and include some light chestnut top. You can include a smidgen of light blue to his wings or abandon them white.

Conclusion

Children adoration kid's shows and it is a typical marvel that they will prone to begin drawing their most loved toon saints at this stage.

A few children will add to their creative gifts through this propensity while different children will in the end quit drawing toons and simply placate themselves with watching them on TV.

As of right now, the individuals who have created and kept up their adoration for toon drawing must be given more consideration regarding assist them with enhancing this ability that would probably be considered as a profession. Expert toon craftsmen today began drawing at an early age, notwithstanding when the TV was not yet well known.

The considerable sketch artist Walt Disney began drawing the world well known Mickey Mouse on the house's carport where he lives while intrigued by the animals circling. Folks ought to support their kids who they have seen to have these one of a kind gifts instead of to be motivation to chasten them for not quitting any and all funny business with their studies.

Here are a few ways you can assist your with kidding enhance their toon drawing:

- Always welcome their work. Thankfulness is a type of prize and for the most part expands the conduct strengthened. They will feel uncommon thusly, and they will realize that you are additionally content with what they are doing.

- Support your youngster's ability. Rather than getting frantic at him attracting his scratch pad and all over the place else, however him a drawing book for his portrayals. Along these lines, he/she won't any longer attract his scratch pad and books however in the drawing book given by you.

- Enroll your youngster on a late spring craftsmanship class. Enlistment on a late spring craftsmanship project work from numerous points of view. To begin with, he gets the opportunity to enhance his aptitude in toon drawing, and he gets the chance to spend his get-away beneficially. Further, you can do different things realizing that he is doing something protected and getting a charge out of it.

You must recall that a great many people began attracting something before figuring out how to compose the first words. Drawing is a novel ability and any child why should seen have it in an early age needs full bolster and comprehension.